OCT 1996

7/97
00
12

110633769

Monterey Public Library

How Artists See
PEOPLE
Boy Girl Man Woman

Colleen Carroll

ABBEVILLE KIDS

A DIVISION OF ABBEVILLE PUBLISHING GROUP

New York London Paris

J
701.1
CAR

*"Painters understand nature and love her
and teach us to see her."*

—VINCENT VAN GOGH

———————

This book is dedicated to the memory of my parents,
James T. Carroll and Theresa M. Vaughn.

I'd like to thank the many people who helped make this book
happen, especially Jackie Decter, Ed Decter, Colleen Mohyde,
and as always, my husband, Mitch Semel.

—COLLEEN CARROLL

JACKET FRONT: Auguste Renoir, *A Girl with a Watering Can* (detail), 1876 (see also pages 14 and 15).
JACKET BACK, CLOCKWISE FROM UPPER LEFT: Norman Rockwell, *Tackled* (detail), 1925 (see also pages 4 and 5); Romare Bearden, *Untitled* (detail), 1988, (see also pages 28 and 29); Alberto Giacometti, *City Square,* 1947–48 (see also pages 24 and 25).

EDITOR: Jacqueline Decter
DESIGNER: Patricia Fabricant
PRODUCTION EDITOR: Abigail Asher
PRODUCTION MANAGER: Lou Bilka

Text copyright © 1996 Colleen Carroll. Compilation, including selection of text and images, copyright © 1996 Abbeville Press. All rights reserved under international copyright conventions. No part of this book may be reproduced or utilized in any form or by any means, electronic or mechanical, including photocopying, recording, or by any information storage and retrieval system, without permission in writing from the publisher. Inquiries should be addressed to

Abbeville Publishing Group, 488 Madison Avenue, New York, N.Y. 10022. The text of this book was set in Stempel Schneidler. Printed and bound in Hong Kong.

First edition
10 9 8 7 6 5 4 3 2 1

Library of Congress Cataloging-in-Publication Data
Carroll, Colleen.
 People : boy, girl, man, woman / Colleen Carroll.
 p. cm. — (How artists see, ISSN 1083-821X)
 Includes bibliographical references.
 Summary: Examines how humans have been depicted in works of art from different time periods and places.
 ISBN 0-7892-0032-5
 1. Humans in art—Juvenile literature.
[1. Humans in art. 2. Art appreciation.]
I. Title. II. Series: Carroll, Colleen.
How artists see.
N7625.5.C37 1996
701'.01—dc20 95-25796

CONTENTS

BOY 4

GIRL 12

MAN 20

WOMAN 28

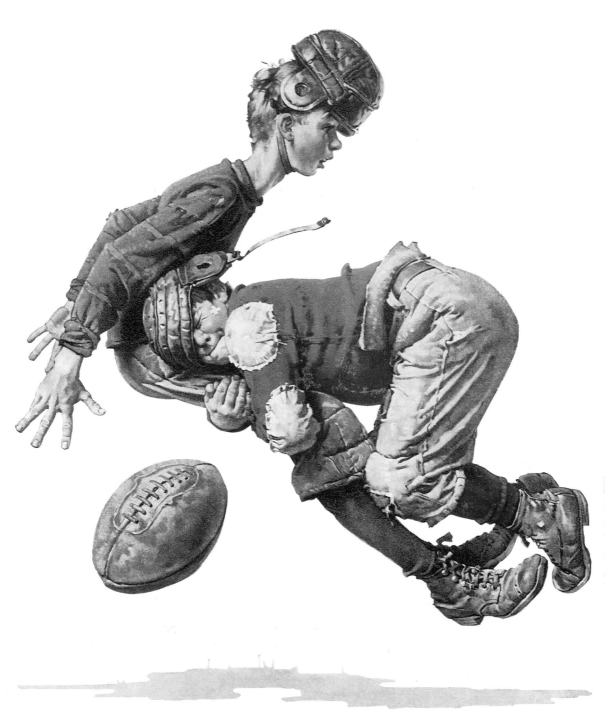

4

TACKLED

by Norman Rockwell

For thousands of years artists have used people as subjects in their work. The most common way for an artist to show people is by making a portrait, which is a painting, photograph, or sculpture of a specific person. As you read this book, you'll see many great examples of portraits and other images of people. Some may look new to you, others may remind you of people you know, and some may even remind you of yourself.

This lively picture of two boys playing football shows a scene filled with speed and movement. Like a photograph that freezes a split second of action, the artist captured the very moment at which one boy is being tackled by another. Look closely at the players' bodies and uniforms. How has the artist shown you the action of this scene? The tackler squints his face and wraps his arms tightly around his opponent's legs. The other boy's expression is quite different. As he flies through the air, his raised eyebrows and open mouth give him a look of surprise. What could he be thinking?

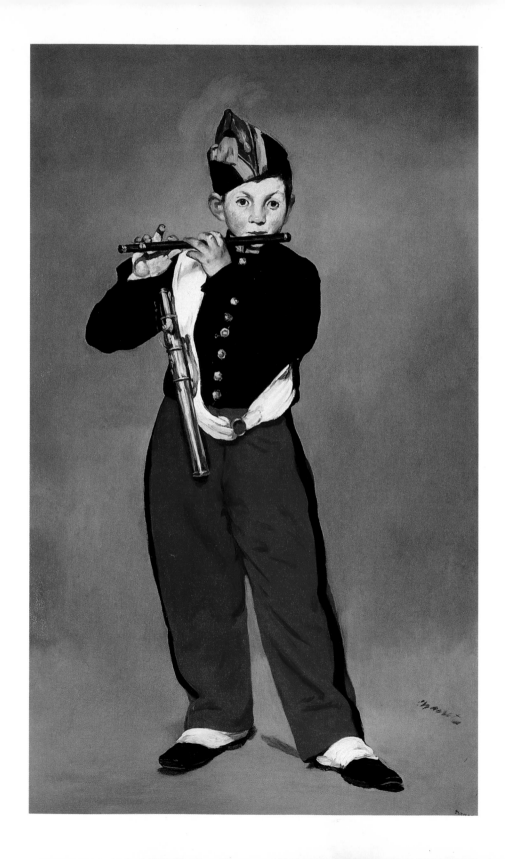

THE FIFE PLAYER

by Edouard Manet

This boy plays a wooden fife as he poses for his portrait in a fancy uniform and colorful hat. Strapped to his chest is a shiny, golden flute that matches the buttons on his black jacket. What other colors can you find? The artist placed the boy against a background of grays and greens to make him stand out in his festive clothing. How would the picture change if the artist had chosen red, black, or white for the background?

The young musician stands confident and proud as he fingers the instrument and blows air into the mouthpiece from his rosy cheeks. Perhaps he is a member of a fife and drum corps that leads great armies into battle. Try to imagine the tune he plays. What does it sound like to you?

SNAP THE WHIP

by Winslow Homer

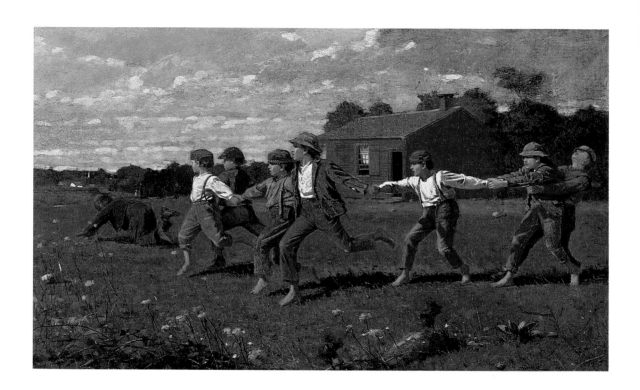

The boys in this picture are playing a game you may have played before. Point to the boy who holds the "whip" as the others spin around. He looks exhausted as his body strains against the force of the whip. Do you think he can hold on much longer? What do you think will happen if he lets go?

The boys seem to be playing in the middle of a big lawn, with lots of room to whirl around in. To show all this space, the artist made the objects that are far away smaller than those that are close up. To see how he did this, use your fingers to measure the height of the boy in the middle and the red house behind him. Which one is bigger?

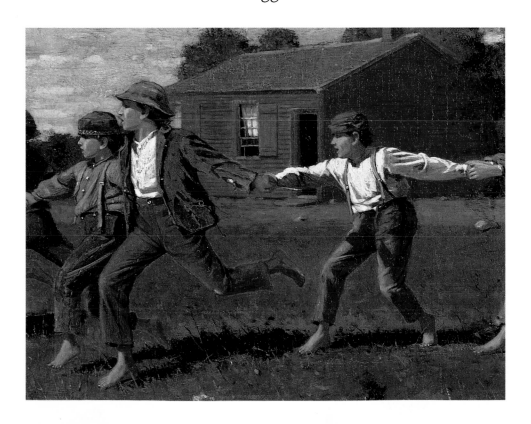

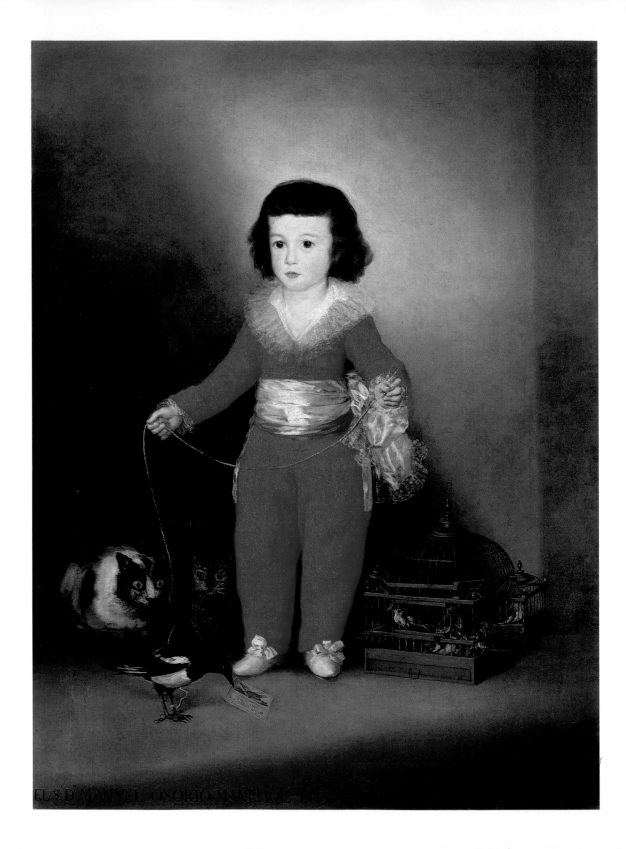

PORTRAIT OF DON MANUEL OSORIO DE ZUÑIGA

by Francisco José de Goya

The young boy in this portrait was a prince who lived many years ago. As he walks his pet magpie on a short leash, other birds watch from the safety of their cage. What other animals are in the picture? How many can you find? Look carefully and count twice, because there's a surprise lurking somewhere in the painting.

If you noticed the eyes of a cat glowing in the shadows, you've found it. Because the artist blended the cat into the dark background, it takes a few moments for your eyes to spot it. The three kitties peer at the magpie with great concentration. If this picture could come to life, what might happen next?

11

LI'L SIS

by William H. Johnson

This is a portrait of the artist's six-year-old niece. She stands next to her favorite doll and holds a fly swatter. Why do you think the artist included these things in the

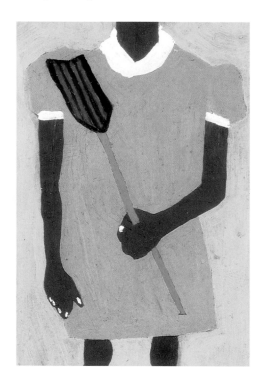

portrait? What do these objects tell you about the little girl? If you were having your portrait made, what objects would you want to include?

The artist painted the girl with bright colors and simple shapes. Trace your finger around her rectangular blue dress. This large area of solid color makes the dress look flat, as if the artist cut it out of paper and pasted it onto the mustard yellow background. Now turn back to *The Fife Player*. He, too, is painted against a plain background. What other similarities can you find? How are the two paintings different?

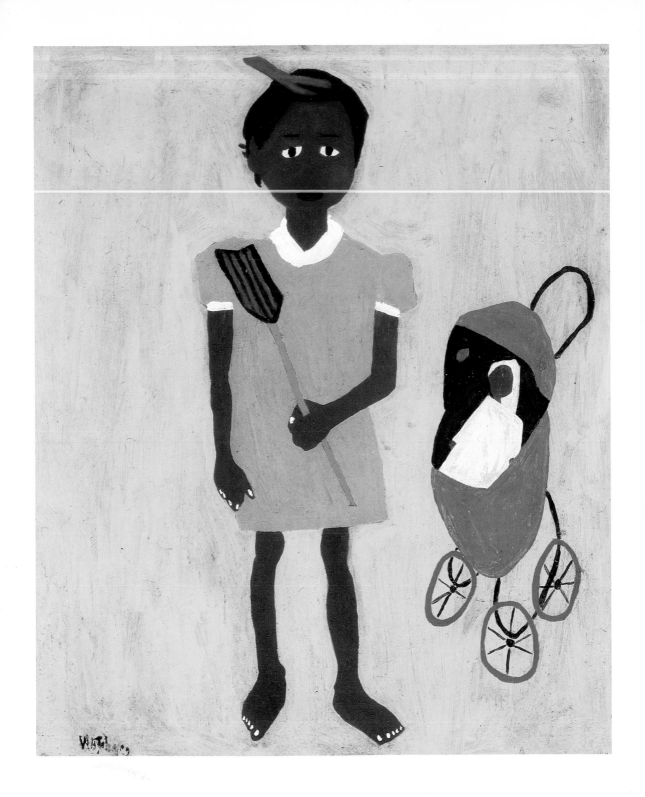

13

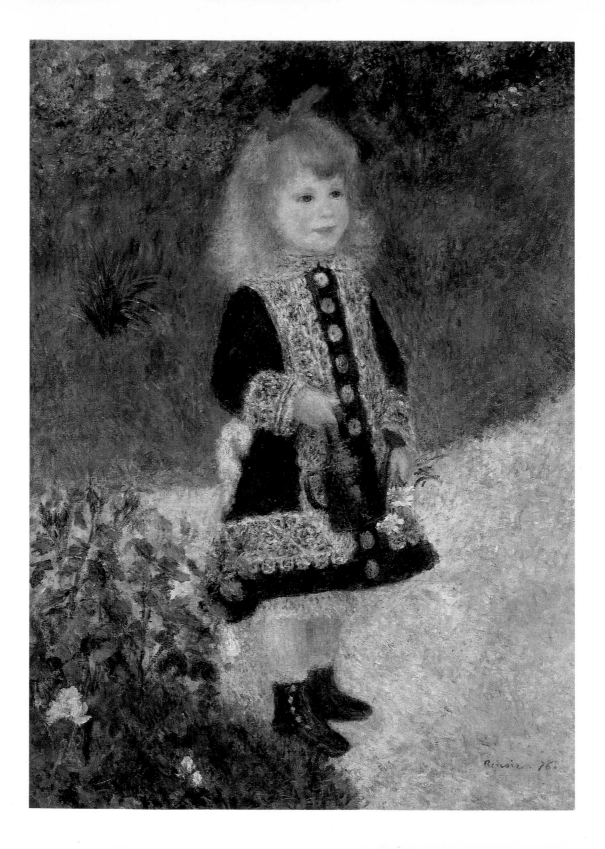

A GIRL WITH A WATERING CAN

by Auguste Renoir

This little girl stands in a sunny garden, ready to water the blooming roses that grow along the path. If you examine this picture very carefully, you'll see that it looks "fuzzy," like a photograph that's out of focus. To create this soft appearance, the artist applied the paint in small dabs of different colors, one beside another. This special brush stroke helps to capture the shimmering light of a sunny day. Point to the areas of the painting that seem to reflect the sunlight.

The girl in this picture holds a watering can and a handful of blossoms. She looks into the distance, perhaps at her mother or father, or at a gardener who tends to the flower beds. Have you ever been in a such a colorful place? Maybe you can start a garden in your own yard or on a sunny windowsill, and grow your very own flowers.

PORTRAIT OF JULIETTE COURBET AS A SLEEPING CHILD

by Gustave Courbet

Have you ever been so tired that you could fall asleep while sitting up? In order for the artist to get close enough to sketch this little girl, perhaps he crept up to her very quietly, or perhaps he asked her to pretend to be asleep.

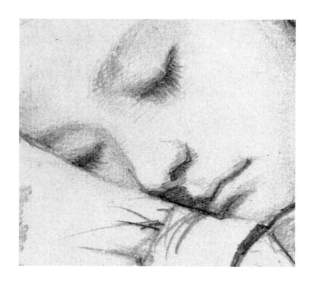

Do you think she is really sleeping or just posing for her portrait?

In this pencil drawing, the artist created areas of light and dark to direct your eye to the girl's sleeping face. Move the tip of your finger around the lightest part of the picture. Because this highlighted area is the center of interest, the artist drew it very precisely. What details can you find?

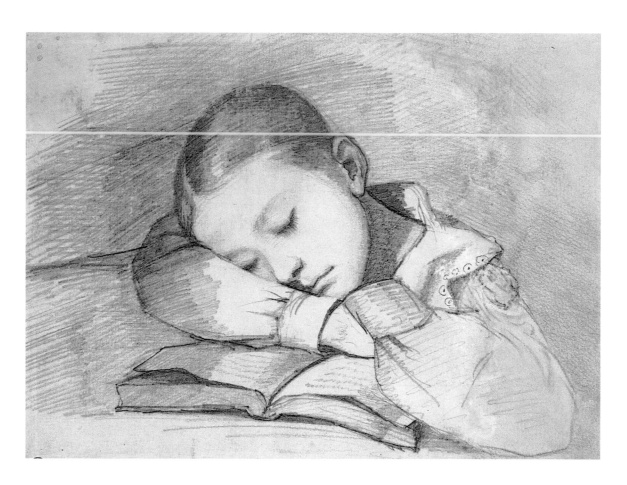

The dark areas of the drawing are just as important as the light ones. Point to the dark part of the sleeve where the girl rests her head. Even though it's just made up of lots of dark lines, this shaded area makes the sleeve appear full and rounded. Where else did the artist use shading to give the picture shape and form?

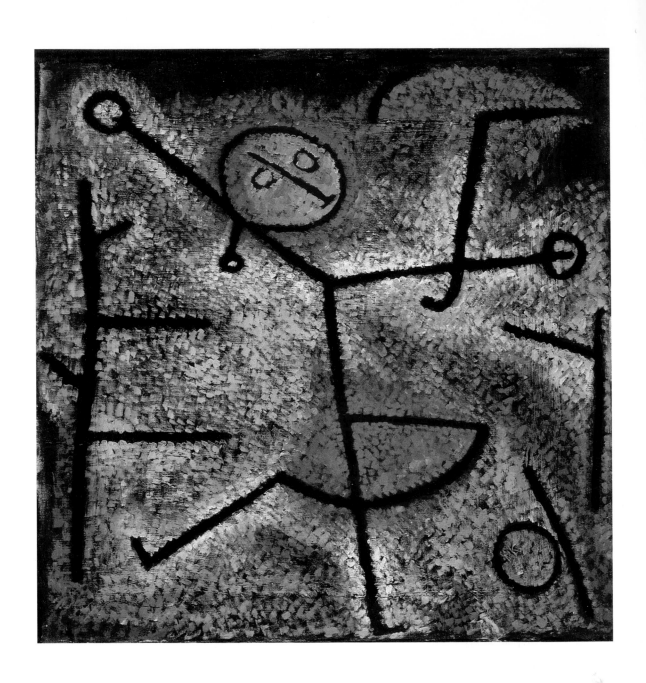

18

DANCING GIRL

by Paul Klee

In this painting of a dancing girl, the artist used just a few lines, shapes, and colors to create a picture full of movement and energy. Do you think she dances to a tune with a strong, fast rhythm or one that is slow and swaying?

To capture the feeling of movement, the artist used lines to guide your eyes in many different directions. Some of the lines curve and bend, some go up and down, and some go sideways. Trace your finger over all the lines you see. Which ones help you understand how the girl moves? Close your eyes and imagine the music, then try to dance to it yourself.

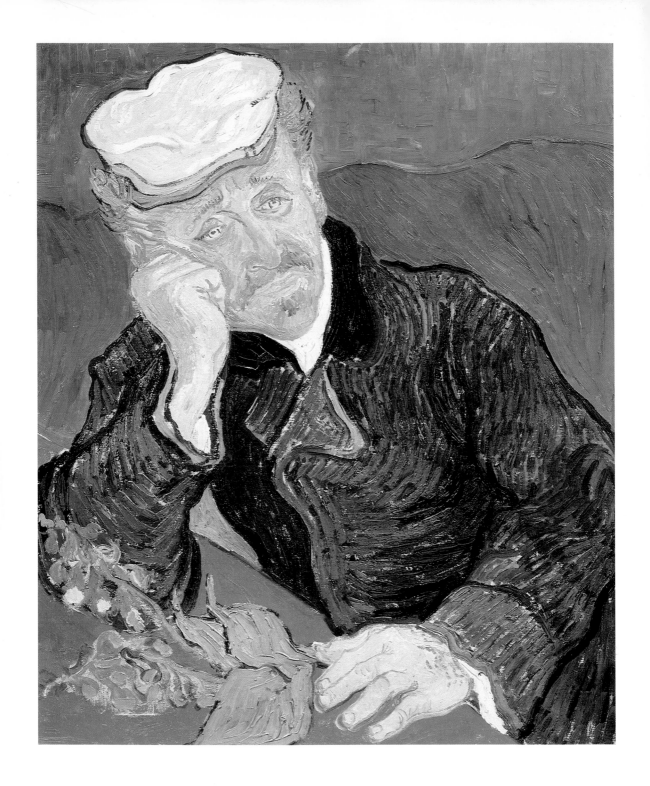

20

DR. PAUL GACHET

by Vincent van Gogh

Even though this man is sitting very still to have his portrait painted, there is a great feeling of motion in this picture. The artist created a sense of movement by making the lines curve and dip in many directions. Move your finger over the wavy lines of the man's blue jacket to feel the path of the painter's brush.

In this portrait, the artist tried to capture the mood of his friend Dr. Gachet. As he stares into the distance, he leans on his hand and wrinkles his brow. What does his facial expression tell you about his thoughts and feelings? What words would you use to describe this man?

THE CARD PLAYERS

by Paul Cézanne

Although this picture is of two men playing a game of cards, the artist was as interested in the shapes he was painting as in the game itself. Trace your finger around all of the circles, squares, and triangles that you see. There are lots of them, so look very carefully. What other shapes can you find?

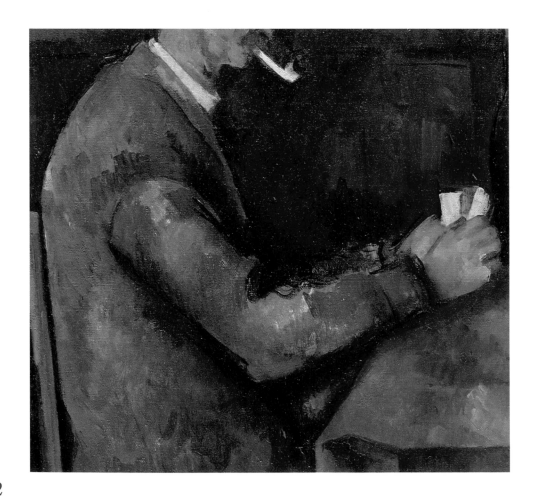

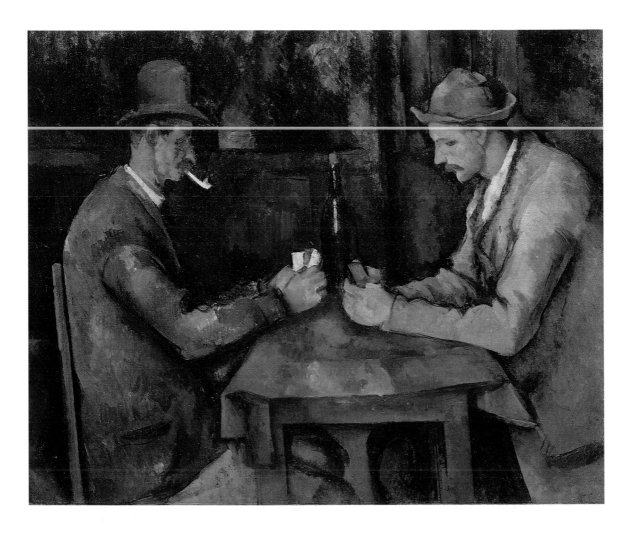

Color is another important part of this painting. At first
glance it appears that the picture is made up mostly of reds
and browns. Now take a closer look. What other colors
do you see? The artist formed people and objects by
applying and layering many different colors of paint. To
understand how the artist placed the colors on the canvas,
look at the man on the left. How many paint "patches"
can you find in his multicolored coat?

CITY SQUARE

by Alberto Giacometti

Some artists like to show people in very unusual ways, as in this sculpture of five people walking through a city square. Four of the people are men. Can you find the woman? This artist wasn't as concerned about making the people look real as about showing how they move

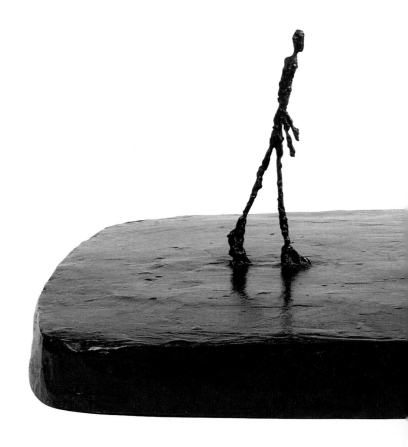

through space. Some of the figures stand straight and tall, while others lean forward slightly as they move. Which ones seem to be walking quickly, and which seem to be taking a leisurely stroll?

Even though these metal figures can't really move, their skinny bodies seem to glide easily through the empty square. What do you think will happen when they meet in the middle?

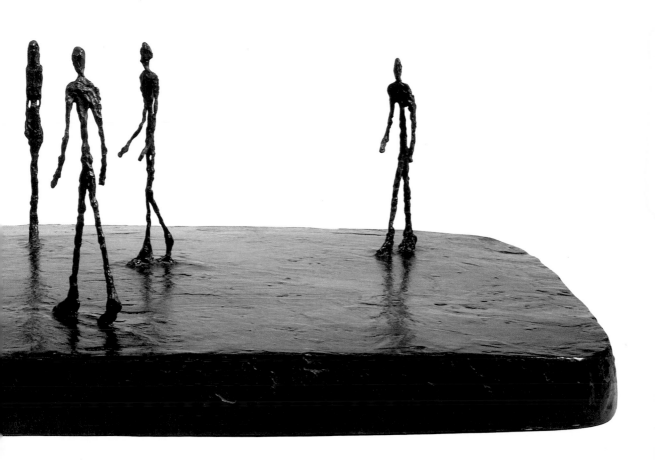

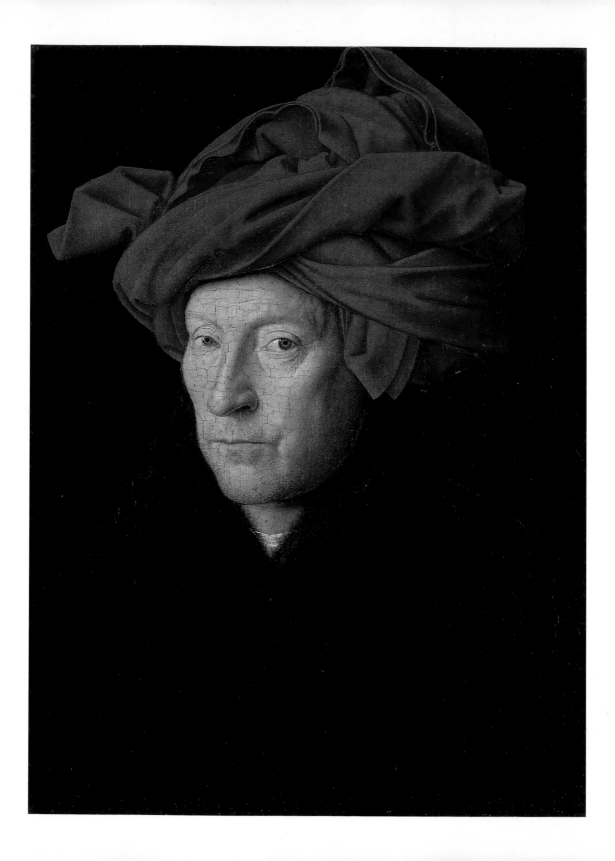

A MAN IN A RED TURBAN

by Jan van Eyck

Some people think the man in this painting is the artist himself. The painting looks so real, it's hard to believe it isn't a photograph. The artist who made it was an expert at showing things as they actually look. The details seem so lifelike that you can almost feel the texture of the folded cloth upon the man's head and the whiskers on his unshaven face. What other textures do you see?

Look back at *Dr. Paul Gachet.* Although it, too, is a portrait of a man with a serious expression, it looks distinctly different from this one. No two artists create in exactly the same way, so each painting has its own unique quality. Which one do you prefer?

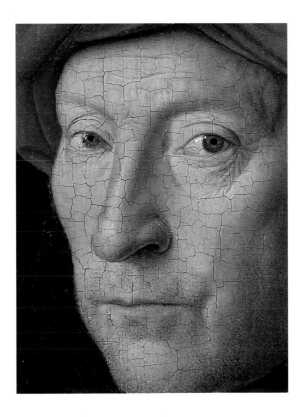

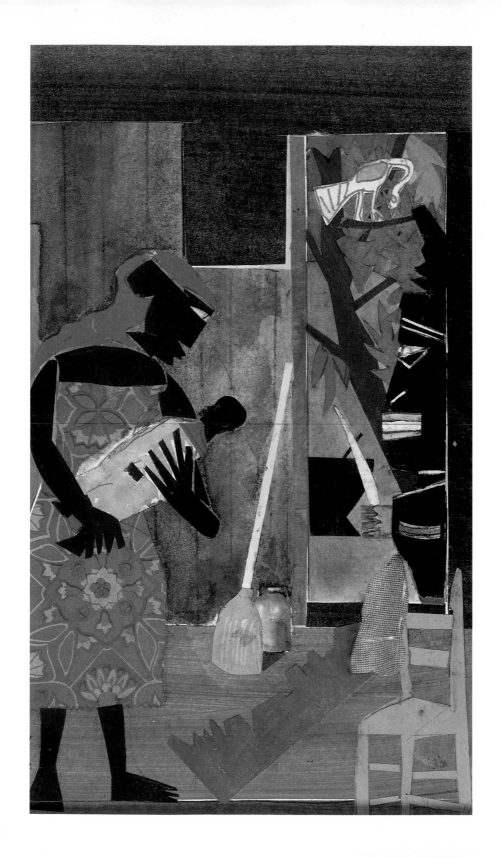

UNTITLED

by Romare Bearden

The subject of mother and child has been a favorite of artists for hundreds of years. In this picture, the woman leans slightly toward the child and cradles him in her large arms. They gaze at each other with great concentration. Perhaps she is rocking the baby to sleep or singing a quiet lullaby. How do you think the baby feels in the arms of such a loving woman?

This artwork is called a collage. It is made up of many pieces of paper that have been cut out and carefully arranged to form the shapes and objects that make up the scene. Some of the pieces are parts of photographs that the artist found in magazines, such as the jug standing behind the broom and the gingham cloth hanging from the chair. Count the colors and patterns. How many can you find? As you look at the picture more closely, you may see some things that you didn't notice at first. For example, look through the open door at the back of the room. What do you see?

WOMAN IN AN ARMCHAIR

by Pablo Picasso

You might think this painting looks more like a jigsaw puzzle than a portrait. But there really is a woman in this picture, and if you look closely you'll find her.

Starting with her hands, trace your finger around the lady as if you were drawing an outline. If you don't see her at first, keep looking, and she will gradually appear to you.

When the artist made this picture he was experimenting with a whole new style of painting. You may have noticed that the woman's body is made up of many small cubes and other shapes. Now go back to the picture and try to find the different parts of the woman's form. What do you notice that you didn't see before?

30

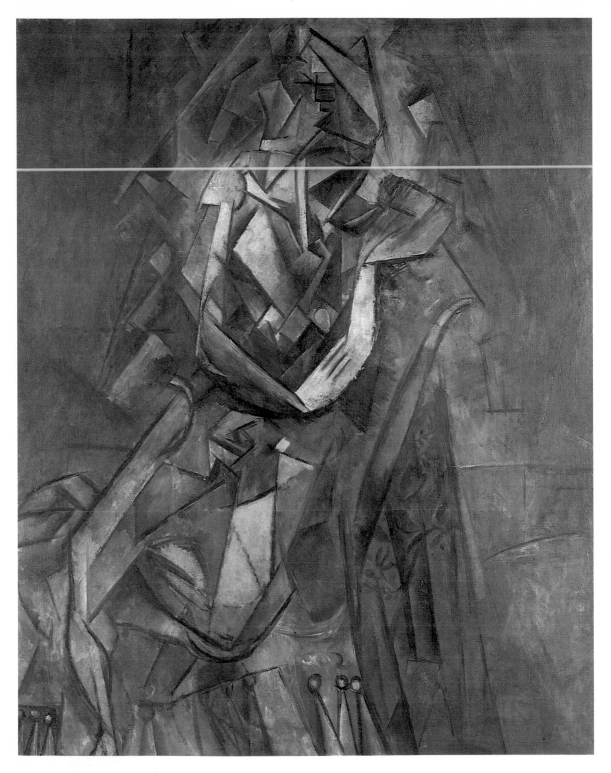

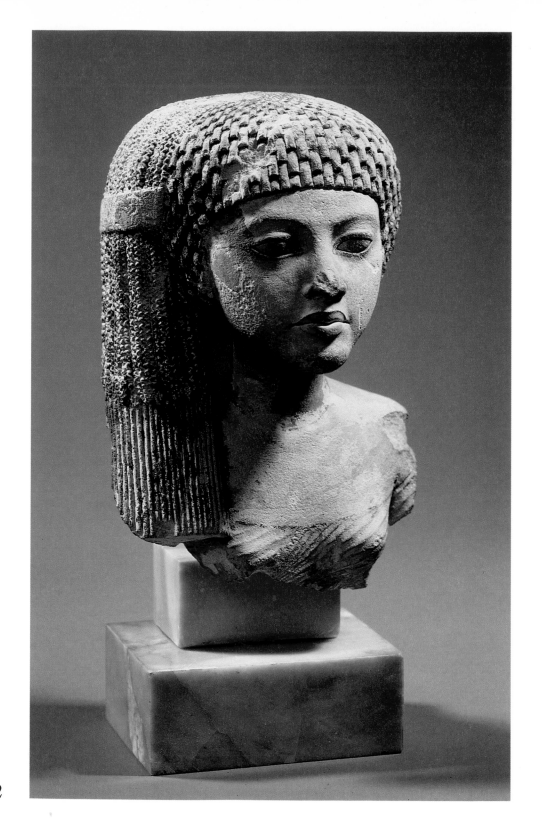

32

HEAD OF A PRINCESS

Ancient Egyptian

This sculpture was made in Egypt more than three thousand years ago and used to be part of a larger statue. Even though it's not in perfect condition, you can see that the artist was a very skilled sculptor. He paid careful attention to the features of the princess's face and the textures of her gown and hair. How many different textures can you find on her finely carved head?

Today this fragment has the natural color of limestone, but when it was made it was brightly painted. You can still see remaining bits of black paint on her hair, eyes, and gown, and small patches of brown on her face and neck. The band in her hair was probably painted a bright gold, and she may have worn a necklace of colorfully painted jewels. To better understand how

she looked long ago, make a crayon drawing of this royal sculpture with colors fit for a princess.

MONA LISA

by Leonardo da Vinci

Of all the paintings of women that have ever been made, this one is the most famous. She's so famous, you've probably seen her before. You may be wondering, what makes her so special? That's a good question, and one that people have been asking for hundreds of years.

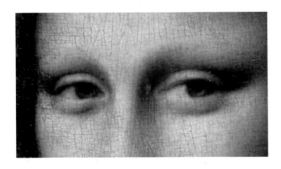

Some people think the rocky landscape covered in a smoky haze gives the painting a mysterious quality. Other people are drawn to the woman's slightly crooked smile, or to the way she stares off to one side. Still others marvel at the skill with which the artist painted the details, such as her graceful hands, the folds of her cloak, and the sheer fabric of her veil. But you can decide for yourself what makes this work of art unique, because, like all the artists you've met here, you have your own special way of seeing.

Now that you've discovered how some artists see people, try creating a portrait of a friend, relative, or even yourself in your own style.

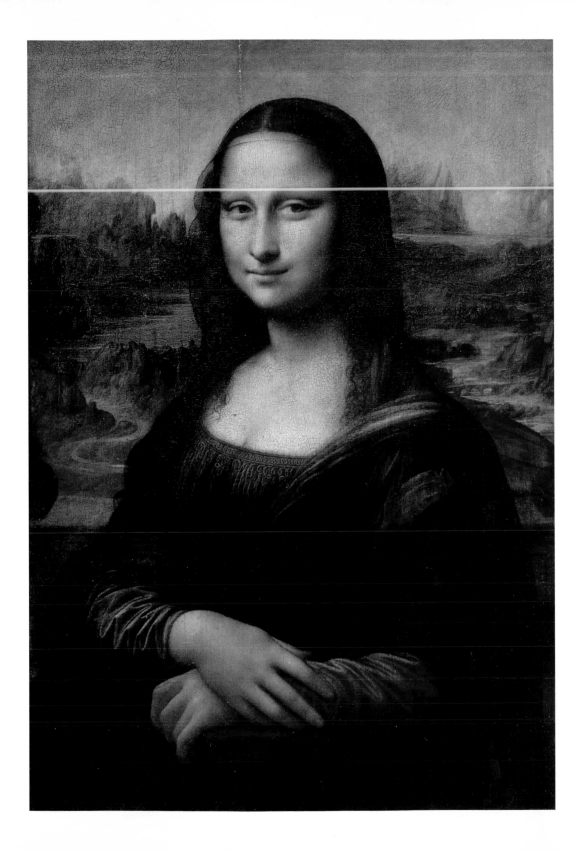

NOTE TO PARENTS
AND TEACHERS

As an elementary school teacher, I had the opportunity to show my students many examples of great art. I was always amazed by their enthusiastic responses to the colors, shapes, subjects, and fascinating stories of the artists' lives. It wasn't uncommon for us to spend twenty minutes looking at and talking about just one work of art. By asking challenging questions, I prompted the children to examine and think very carefully about the art, and then quite naturally they would begin to ask all sorts of interesting questions of their own. These experiences inspired me to write this book and the other volumes in the *How Artists See* series.

How Artists See is designed to teach children about the world by looking at art, and about art by looking at the world through the eyes of great artists. The books encourage children to look critically, answer—and ask—thought-provoking questions, and form an appreciation and understanding of an artist's vision. Each book is devoted to a single subject so that children can see how different artists have approached and treated the same theme and begin to understand the importance of individual style.

Because I believe that children learn most successfully in an atmosphere of exploration and discovery, I've included questions

that encourage them to formulate ideas and responses for themselves. And because people's reactions to art are based on their own personal aesthetic, most of the questions are open-ended and have more than one answer. If you're reading aloud to your children or students, give them ample time to look at each work and formulate a response; it certainly is not necessary to read the whole book in one sitting. Like a good book or movie, art can be enjoyed over and over again, each time with the possibility of revealing something that wasn't seen before.

You may notice that dates and other historical information are not included in the main text. I purposely omitted this information in order to focus on the art and those aspects of the world it illustrates. For children who want to learn more about the artists whose works appear in the book, short biographies are provided at the end, along with suggestions for further reading and a list of museums where you can see additional works by each artist.

After reading *How Artists See People,* children can do a wide variety of related activities to extend and reinforce all that they've learned. In addition to the simple activities I've suggested throughout the main text, they can draw or paint a self-portrait, or create stories using the people in their favorite images as the heroes or villains. Since the examples shown here are just a tiny fraction of the great works of art that feature people as their subject, children can go on a scavenger hunt through museums and the many wonderful art books in your local library to find other images of people.

I hope that you and your children or students will enjoy reading and rereading this book and, by looking at many styles of art, discover how artists share with us their unique ways of seeing and depicting our world.

ARTISTS' BIOGRAPHIES

(in order of appearance)

If you'd like to know more about the artists in this book, here's some information to get you started:

NORMAN ROCKWELL (1894–1978)

If every picture tells a story, then American illustrator Norman Rockwell told hundreds of them during his career. Illustrators are artists who make pictures for books, magazines, and newspapers. Because so many people were able to see his paintings and drawings on the covers of popular magazines, his work became very well known. People looked forward to his sweet and funny scenes of everyday life—children playing, people working, and family holidays. Rockwell often asked friends and neighbors to model for him, and this lively cast of characters shows up again and again in his pictures.

EDOUARD MANET (1832–1883)

Manet (pronounced *ma-NAY*) believed that artists must "be of their own time and work with what they see," and paint in new and bold ways. Many people didn't agree with him. Some of his paintings made people very angry because of just how new they looked. This French artist put his paint on in thick, free strokes of the brush that made his subjects look flat. Most people who saw his work weren't used to this new style, but a small group of painters thought it was wonderful, and learned many lessons from Manet that they used in their own paintings. These young painters came to be known as the Impressionists (look back at *Girl with a Watering Can* by Renoir), and Manet as the "father of Impressionism."

WINSLOW HOMER (1836–1910)

As a young artist Winslow Homer was a magazine illustrator. Later he began painting scenes from daily life. His first paintings were of soldiers of the American Civil War. His paintings look very real. In fact, the style he is known for is called Realism. He liked to use watercolor paints to sketch scenes from nature, especially the seaside, and he used some of these watercolor sketches as ideas for his oil paintings. Winslow Homer is one of America's most beloved artists because he was able to capture the spirit of a young and beautiful nation in his art.

FRANCISCO JOSÉ DE GOYA (1746–1828)

This Spanish artist is best known for pictures of kings, queens, wars, and bullfights. His paintings show people as they really look. One of his portraits of the Spanish royal family makes the group look so homely that it was a miracle he didn't lose his job as the court painter. Some of Goya's most famous works are prints that express his feelings about the world, such as the horrors of war. Many artists who lived long after Goya said his work helped them to form their own style, such as Edouard Manet (look back at *The Fife Player*).

WILLIAM H. JOHNSON (1901–1970)

Large, flat shapes, bold colors, black outlines, thick paint, and a lively spirit are the things that make William H. Johnson's painting so special. He liked to call his work "primitive," because it appeared to be done in a very simple way. This African-American artist used the events and people in his own life and his favorite stories from the Bible as subjects for his paintings.

AUGUSTE RENOIR (1841–1919)

This French painter had a gift for using color in fresh, new ways. Because he didn't mix his colors or use dark outlines, his pictures look soft and fuzzy. Renoir (pronounced *ren-WAH*) is known for paintings of women and scenes of people having fun outdoors. He was part of the group of painters known as the Impressionists, who painted scenes that show light and color in a natural way.

GUSTAVE COURBET (1819–1877)

Courbet (pronounced *cor-BAY*) was a French artist who liked to break the rules. Before Courbet's time, most artists made pictures of stories from history, myths, or religion. He believed that painters should paint subjects from real life. Those artists who paint things as they are in real life are called Realists, and Courbet was one of the first Realist painters. Many of his paintings are nature scenes filled with bright light and dark shadows. In his time some people didn't appreciate his bold way of painting, but he paved the way for the next generation of French artists, who would take painting in a brand new direction.

PAUL KLEE (1879–1940)

Can you imagine what it would be like to "take a line for a walk"? That's how this Swiss artist and teacher described his style of painting. Paul Klee (pronounced *clay*) used lines and shapes to create paintings that seem to come from a dreamworld. He loved the way children made drawings, and his own work sometimes resembles children's art. Klee was fond of painting pictures of children, fish, and creatures from his vivid imagination.

VINCENT VAN GOGH (1853–1890)

Even though this Dutch artist painted for only seven years, he left behind hundreds of paintings and drawings that are among the world's most famous and beloved artworks. Vincent van Gogh (pronounced *van-GO*) used bright colors and thick brush strokes. He liked to paint outdoors in full sunlight, and often painted two or more pictures a day. His brother Theo worked for an art dealer, and sent Vincent paints and canvas so he could spend most of his time painting. The artist's great energy can be seen in his many portraits, still lifes, and landscapes, all of which are bursting with movement and feeling. Even though people didn't appreciate van Gogh's art during his lifetime, today he is thought to be one of the greatest artists who ever lived.

PAUL CÉZANNE (1839–1906)

The paintings of this French artist made people look at ordinary things in a whole new way. Cézanne (pronounced *say-ZON*) made pictures of people, landscapes, and still lifes from simple shapes, outlines, and patches of color that showed many different angles at one time. One of his most famous series of paintings is of a mountain that seems to be made out of many blocks of color. He painted this mountain over and over again during his life, and the blocks of paint became larger and looser with each canvas. Many artists, including Pablo Picasso (look back at *Woman in an Armchair*), said that Cézanne's work helped them form their own style of painting.

ALBERTO GIACOMETTI
(1901–1966)

This sculptor and painter from Switzerland began to draw as a young boy and started making sculpture when he was just thirteen years old. As a young man, Giacometti (pronounced *ja-coe-MEH-tee*) made strange sculptures that seemed to come from a scary dream. In one of his most famous sculptures, *The Palace at 4 A.M.,* a lady in a dress, a set of bones, and the skeleton of a bird are all inside a house made of sticks. He is best known for his skinny bronze sculptures of sad-looking men and women walking alone or in groups.

JAN VAN EYCK
(C. 1390–1441)

A remarkable ability to show people, places, and things as they really look is what marks the style of this "old master" Flemish painter. He was one of the first artists ever to use oil paint, and some people believe he may have invented it. Many artists who lived long after van Eyck (pronounced *van-IKE*) learned important lessons by looking at his paintings, such as how to show light and shadow and how to capture a person's personality in a portrait.

ROMARE BEARDEN
(1912–1988)

The American artist Romare Bearden once said, "I think the artist has to be something like a whale, swimming with his mouth wide open, absorbing everything until he has what he really needs." Bearden absorbed what he saw around him and used his memories to create art. He spent most of his childhood in Harlem, a neighborhood in New York City. After college he attended art school and began to search for his own individual style. He loved music, especially jazz, and would listen to it as he worked, trying to express its rhythms in his art. In the 1960s Bearden began to make collages that show the hopes, dreams, and experiences of African Americans. His collages combine many different materials, such as photographs, paper, fabric, and paint. He is best known for these beautiful works of art, which celebrate the simple beauty of daily life.

PABLO PICASSO
(1881–1974)

Picasso (pronounced *pea-KAH-so*) was born in Spain, but for most of his life he lived and painted in France. Many people consider him the most important artist of the twentieth century. Picasso began to draw as a young boy, and after attending art school he moved to France, where he would help change the course of art. Throughout his long life he explored many different styles of art, but he is perhaps most known for a style called Cubism, in which the subject seems to be broken into many shapes and is seen from many angles at once. Picasso lived to be an old man, and his many paintings, drawings, sculptures, and ceramics can be seen in museums all over the world.

ANCIENT EGYPTIAN SCULPTURE
REIGN OF AMENHOTEP IV (AKHENATEN)/18TH DYNASTY

Pyramids, sphinxes, and great stone temples are just some of the wonders of Ancient Egypt, a civilization that flourished for more than two thousand years and produced some of history's most amazing works of art. During the reign of one of Egypt's greatest pharaohs, Akhenaten, craftsmen from all over the land were hard at work making sculpture to adorn the king's tombs and temples. They were beginning to use exciting new materials, such as bronze and glass, in addition to the slate and limestone that had been used for centuries by earlier sculptors. Although many different types of sculpture were made during Akhenaten's seventeen years as pharaoh, the most common were carved stone reliefs showing him in happy scenes with his family or making offerings to the sun god, Aten.

LEONARDO DA VINCI
(1452–1519)

This Italian painter, scientist, inventor, engineer, and architect was one of the greatest thinkers the world has ever known. Born with a burning curiosity to know about everything he saw, Leonardo da Vinci (pronounced *dah-VIN-chee*) made careful drawings of the human body, animals, machines, and even the weather. Some of his drawings are of strange contraptions that Leonardo couldn't build in his own time but that were the earliest ideas for machines we have today, such as the airplane. His most famous painting, *Mona Lisa,* must have been one of his favorites—he carried it with him on a long trip from his home in Italy all the way to France.

SUGGESTIONS FOR FURTHER READING

The following children's titles are excellent sources for learning more about the artists presented in this book.

FOR EARLY READERS (AGES 4–7)

Anholt, Laurence. *Camille and the Sunflowers: A Story about Vincent van Gogh.* Hauppauge, New York: Barron's, 1994.
Camille Roulin, the young boy whose family befriended van Gogh, describes his experiences with the great Dutch artist while he lived and painted in Arles, France.

Everett, Gwen. *Li'l Sis and Uncle Willie.* Washington, D.C.: Smithsonian Institution/National Museum of American Art, 1991.
Illustrated with the paintings of William H. Johnson, this engaging story is based on actual events and experiences from the artist's life, as told by his "almost six"-year-old niece.

Provensen, Alice, and Martin Provensen. *Leonardo da Vinci.* New York: The Viking Press, 1984.
This delightful pop-up book beautifully describes the brilliance, curiosity, and spirit of the great Renaissance artist and scientist.

Venezia, Mike. *Picasso.* Getting to Know the World's Greatest Artists series. Chicago: Children's Press, 1988.
This easy-to-read biography combines color reproductions and humorous illustrations to capture the personality and talent of the famous twentieth-century artist. Included in this series is *Paul Klee,* also by Mike Venezia.

FOR INTERMEDIATE READERS (AGES 8–10)

Dubelaar, Thea, and Ruud Bruijn. *Looking for Vincent.* New York: Checkerboard Press, 1992.
A boy and his eccentric aunt go on a quest to purchase a painting by Vincent van Gogh, and in the process learn about the artist's extraordinary life.

Mason, Antony. *Cézanne: An Introduction to the Artist's Life and Work.* Famous Artists series. Hauppauge, New York: Barron's, 1995.
This wonderful reference book provides a wealth of information about the life and work of the French painter who helped shape the course of twentieth-century art. Other titles in this series include *Leonardo da Vinci, Pablo Picasso,* and *Vincent van Gogh.*

Paint and Painting. Voyages of Discovery series. New York: Scholastic, Inc., 1994.
The history and techniques of painting are described in this beautifully designed, interactive book.

Raboff, Ernest. *Auguste Renoir.* Art for Children series. New York: HarperCollins, 1988.
This informative book describes the life, times, and style of the French Impressionist painter. Other titles in this series include *Vincent van Gogh, Paul Klee, Pablo Picasso,* and *Leonardo da Vinci.*

FOR ADVANCED READERS (AGES 11+)

Berman, Avis. *James McNeill Whistler.* First Impressions series. New York: Harry N. Abrams, Inc., 1993.
This biography gives a thorough introduction to the painter's interesting life and work.

Mühlberger, Richard. *What Makes a Goya a Goya.* New York: The Metropolitan Museum of Art and Viking, 1994.
The life and work of the Spanish painter is explored in depth and in a way that teaches children how to recognize the artist's unique style. Other artists featured in the series include Leonardo da Vinci, Pablo Picasso, Claude Monet, and Vincent van Gogh.

Skira-Venturi, Rosabianca. *A Weekend with Leonardo da Vinci.* New York: Rizzoli, 1992.
This informative and clever book takes you back in time to meet the Italian artist, who tells you of his life and work. Also in this series: *A Weekend with Renoir* and *A Weekend with van Gogh* by Skira-Venturi; *A Weekend with Winslow Homer* by Ann Keay Beneduce; and *A Weekend with Picasso* by Florian Rodari.

WHERE TO SEE THE ARTISTS' WORK

ANCIENT EGYPTIAN SCULPTURE

- Ägyptisches Museum, Berlin
- The Brooklyn Museum, New York
- Egyptian Museum, Cairo
- The John Paul Getty Museum, Malibu, California
- Louvre, Paris
- The Metropolitan Museum of Art, New York

ROMARE BEARDEN

- The Carnegie Museum of Art, Pittsburgh
- High Museum, Atlanta
- Mint Museum of Art, Charlotte, North Carolina
- The Studio Museum, New York

PAUL CÉZANNE

- Allen Memorial Art Museum, Oberlin College, Oberlin, Ohio
- Arkansas Art Center, Little Rock
- The Art Institute of Chicago
- Dallas Museum of Art
- Kimbell Art Museum, Fort Worth
- Louvre, Paris
- Musée d'Orsay, Paris
- Museum of Modern Art, New York
- Timken Museum of Art, San Diego
- University of Rochester Memorial Art Gallery, Rochester, New York

GUSTAVE COURBET

- Arnot Art Museum, Elmira, New York
- Baltimore Museum of Art
- Louvre, Paris
- The Metropolitan Museum of Art, New York
- Musée d'Orsay, Paris
- Museum of Fine Arts, Springfield, Massachusetts
- Oklahoma City Art Museum
- Petit Palais, Paris

JAN VAN EYCK

- Louvre, Paris
- The Metropolitan Museum of Art, New York
- Museum of Art History, Vienna
- National Gallery, London
- The National Gallery of Art, Washington, D.C.
- Saint Bavo, Ghent, Belgium

ALBERTO GIACOMETTI

- Alberto Giacometti Foundation, Zurich
- Albright-Knox Art Gallery, Buffalo
- Art Gallery of Ontario, Toronto
- The Art Institute of Chicago
- Bünder Kunstmuseum, Chur, Switzerland

- Carnegie Museum of Art, Pittsburgh
- Peggy Guggenheim Collection, Venice
- Solomon R. Guggenheim Museum, New York
- Museum of Modern Art, New York
- Tate Gallery, London

VINCENT VAN GOGH

- The Art Institute of Chicago
- Dallas Museum of Art
- The John Paul Getty Museum, Santa Monica, California
- Solomon R. Guggenheim Museum, New York
- The Metropolitan Museum of Art, New York
- Musée d'Orsay, Paris
- Museum of Modern Art, New York
- National Gallery of Art, Washington, D.C.
- National Museum Vincent van Gogh, Amsterdam
- The Phillips Collection, Washington, D.C.
- Rijksmuseum Kröller-Müller, Otterlo, Netherlands
- Saint Louis Art Museum
- Norton Simon Museum of Art, Pasadena, California

FRANCISCO JOSÉ DE GOYA

- Kimbell Art Museum, Fort Worth
- Louvre, Paris
- Meadows Museum, Southern

Methodist University, Corpus Christi, Texas
- The Metropolitan Museum of Art, New York
- Musée des Beaux-Arts, Lille, France
- Prado Museum, Madrid
- Norton Simon Museum of Art, Pasadena, California
- University of Kentucky Art Museum, Lexington

WINSLOW HOMER

- Addison Gallery of Art, Phillips Academy, Andover, Massachusetts
- Amon Carter Museum, Fort Worth
- Arizona State University Art Museum, Tempe
- Delaware Art Museum, Wilmington
- Freer Gallery of Art, Smithsonian Institution, Washington, D.C.
- Charles and Emma Frye Art Museum, Seattle
- National Museum of American Art, Smithsonian Institution, Washington, D.C.
- North Carolina Museum of Art, Raleigh, North Carolina
- Pennsylvania Academy of the Fine Arts, Philadelphia
- Portland Museum of Art, Portland, Maine
- Wichita Art Museum, Wichita, Kansas

WILLIAM H. JOHNSON

- The Gallery of Art, Howard University, Washington, D.C.
- Hampton University Museum, Hampton, Virginia
- National Museum of American Art, Smithsonian Institution, Washington, D.C.
- Carl Van Vechten Gallery of Fine Arts, Fisk University, Nashville

PAUL KLEE

- The Art Institute of Chicago
- Solomon R. Guggenheim Museum, New York
- Kunsthalle, Hamburg, Germany
- Kunstmuseum, Bern
- Los Angeles County Museum of Art
- Museum of Modern Art, New York
- The Phillips Collection, Washington, D.C.

LEONARDO DA VINCI

- Fresno Metropolitan Museum, Fresno, California
- Louvre, Paris
- The Metropolitan Museum of Art, New York
- National Gallery, London
- National Gallery of Art, Washington, D.C.
- Santa Maria delle Grazie, Milan
- The Uffizi Gallery, Florence

EDOUARD MANET

- Courtauld Institute Galleries, London
- Charles and Emma Frye Art Museum, Seattle
- Heckscher Museum, Huntington, New York
- The Metropolitan Museum of Art, New York
- Musée d'Orsay, Paris
- Norton Simon Museum of Art, Pasadena, California

PABLO PICASSO

- Albright-Knox Art Gallery, Buffalo
- Arkansas Art Center, Little Rock
- Art Gallery of Ontario, Toronto
- The Art Institute of Chicago
- Dallas Museum of Art
- Solomon R. Guggenheim Museum, New York
- Los Angeles County Museum of Art
- McNay Art Museum, San Antonio
- The Metropolitan Museum of Art, New York
- Munson-Williams-Proctor Institute Museum of Art, Utica, New York
- Musée d'Orsay, Paris
- Musée Picasso, Paris
- Museum of Modern Art, New York
- National Gallery, Prague
- Philadelphia Museum of Art
- Phoenix Art Museum
- The Picasso Museum, Antibes, France
- Carl Van Vechten Gallery of Fine Arts, Fisk University, Nashville

AUGUSTE RENOIR

- Arkansas Art Center, Little Rock
- Dallas Museum of Art
- Charles and Emma Frye Art Museum, Seattle
- Solomon R. Guggenheim Museum, New York
- The Metropolitan Museum of Art, New York
- Musée d'Orsay, Paris
- National Gallery of Art, Washington, D.C.
- Philadelphia Museum of Art
- The Phillips Collection, Washington, D.C.
- Norton Simon Museum of Art, Pasadena, California

NORMAN ROCKWELL

- Midwest Museum of American Art, Elkhart, Indiana
- The Norman Rockwell Museum, Stockbridge, Massachusetts

CREDITS *(listed in order of appearance)*

Norman Rockwell (1894–1978). *Tackled,* 1925. Oil on canvas, 29½ × 25½ in. (75 × 65 cm), Norman Rockwell Museum, Stockbridge, Mass. Printed by permission of the Norman Rockwell Family Trust. Copyright © 1925 the Norman Rockwell Family Trust. Edouard Manet (1832–1883). *The Fife Player,* 1886. Oil on canvas, 63⅜ × 38¼ in. (161 × 97 cm), Musée d'Orsay, Paris. Winslow Homer (1836–1910). *Snap the Whip,* 1872. Oil on canvas, 12 × 20 in. (30.5 × 50.8 cm), The Metropolitan Museum of Art, New York; Gift of Christian A. Zabriskie, 1950. Francisco José de Goya (1746–1828). *Don Manuel Osorio de Zuñiga,* 1787. Oil on canvas, 50 × 40 in. (127 × 102 cm), The Metropolitan Museum of Art, New York; The Jules Bache Collection, 1949. William H. Johnson (1901–1970). *Li'l Sis,* 1944. Oil on board, 26 × 21¼ in. (66 × 54 cm), National Museum of American Art, Smithsonian Institution, Washington, D.C.; Gift of the Harmon Foundation. Photograph courtesy of Art Resource, New York. Auguste Renoir (1841–1919). *A Girl with a Watering Can,* 1876. Oil on canvas, 39½ × 28¾ in. (100.3 × 73.2 cm), National Gallery of Art, Washington, D.C.; Chester Dale Collection. © 1995 Board of Trustees, National Gallery of Art, Washington. Gustave Courbet (1819–1877). *Portrait of Juliette Courbet as a Sleeping Child,* c. 1841. Graphite on paper, 7⅞ × 10¼ in. (20 × 26 cm), Musée d'Orsay, Paris. Paul Klee (1879–1940). *Dancing Girl,* 1940. Oil on cloth, 20¼ × 20¼ in. (51.2 × 51.2 cm), The Art Institute of Chicago. Gift of George B. Young. Photograph © 1994 The Art Institute of Chicago, all rights reserved. © 1995 Artists Rights Society (ARS), New York/VG Bild-Kunst, Bonn. Vincent van Gogh (1853–1890). *Dr. Paul Gachet,* June 1890. Oil on canvas, 26¾ × 22⅜ in. (68 × 57 cm), Musée d'Orsay, Paris. Paul Cézanne (1839–1906). *The Card Players,* c. 1890–95. Oil on canvas. 18½ × 22⅜ in. (47 × 57 cm), Musée d'Orsay, Paris. Alberto Giacometti (1901–1966). *Piazza,* 1947–48 (cast 1948–49). Bronze, base: 25 × 17 in. (64 × 43 cm), height of tallest figure: 8 in. (20 cm), The Solomon R. Guggenheim Foundation, New York, Peggy Guggenheim Collection, Venice, 1976. Photograph by David Heald © The Solomon R. Guggenheim Foundation, New York. © 1995 Artists Rights Society (ARS), New York/ADAGP, Paris. Jan van Eyck (1390–1441). *Portrait of a Man in a Red Turban,* 1433. Oil on panel, 10¼ × 7½ in. (33 × 26 cm), National Gallery, London. Romare Bearden (1912–1988). *Untitled,* 1988. Watercolor on paper collage on board, 15¼ × 9 in. (38.7 × 22.9 cm), Collection of Robert E. Abrams; courtesy estate of Romare Bearden, ACA Galleries, New York and Munich. Pablo Picasso (1881–1973). *Woman in an Armchair,* 1910. Oil on canvas, 37 × 29½ in. (94 × 75 cm), National Gallery, Prague. A.K.G. Berlin/Superstock. © 1995 Artists Rights Society (ARS), New York/SPADEM, Paris. Reign of Amenhotep/Akhenaten, *Head of a Princess,* c. 1365–49 B.C. (18th Dynasty). Painted Limestone, 6⅛ in. high (15.4 cm), Louvre, Paris. Leonardo da Vinci (1452–1519). *Mona Lisa* (also called *La Gioconda*), c. 1503–6. Oil on panel, 30¼ × 21 in. (76.8 × 53.3 cm), Louvre, Paris.